MARKER RENDERING

BY TODD MURRISON

Walter Foster Publishing, Inc.
23062 La Cadena Drive, Laguna Hills, California 92653

TABLE OF CONTENTS

Introduction 3

Materials 4

Recommended Application 6

Multicolor Gradation Comparison 7

Exercise #1: Rendering a Cube in Gray Tones 8

How to Render Cylinders, Cones, and Spheres 10

Shadows 11

The Importance of Reflective Light and Why It Occurs 12

Exercise #2: Cylinder, Cone, and Sphere 13

How to Make Invisible Repairs to Your Drawings 14

Lettering— Why It Is So Important 16

Exercise #3: Wine Bottle 18

Rendering People 20

Men's Faces 22

Women's Faces 23

Children 24

Exercise #4: Fashion 26

Retail Layouts 28

Exercise #5: Landscapes 30

Exercise #6: Still Life 34

Storyboards 38

Introduction to "Bob-O" Cereal 39

"New York Style" Storyboards 42

Animatics 43

Exercise #7: High-Realism Rendering 44

Exercise #8: Automobiles 46

Exercise #9: Interior Renderings 50

Exercise #10: Exterior Renderings 54

Tricks of the Trade 58

Creating Special Effects and Textures 59

How to Create Your Own Markers 60

Liquid Frisket/Masking 62

Professional Presentations 63

I'd Like to Thank. . . 64

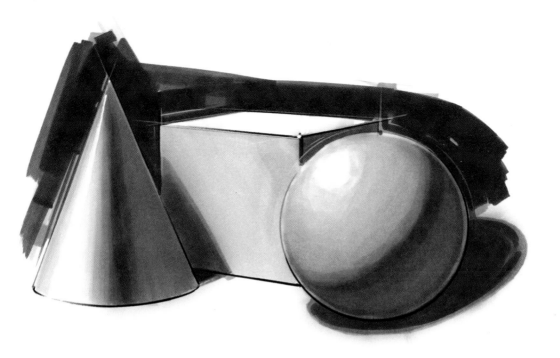

INTRODUCTION

Marker rendering is best defined as an artistic approach centering around impression and illusion. Using this unique medium, one can quickly visualize, emphasize, and minimize three-dimensional subjects and concepts on two-dimensional paper or vellum.

Regardless of skill level, artists, graphic designers, illustrators, architects, interior designers, and students will find this book of demonstrations, hints, and "tricks of the trade" to be a helpful reference.

Terms such as "less is more," "crisp," and "exciting" have often been used to describe professional rendering. The novice soon discovers, as familiarity with the medium develops, that a direct approach provides the best foundation for successful work. Experience, feedback, and observing other artists' work will lead to the most professional level of rendered artwork, consisting of the following components: the use of broad, confident marker strokes; the retention of white space; the creative contrast of colors and tones; and, in the final stage, the achievement of sharpness and detail through fine-tip markers.

As with any discipline, a trained eye will develop with practice and perseverance, so try not to become discouraged. The best advice is to have fun with these exercises and techniques and develop a style that is unique to you. A positive attitude will certainly enhance and be reflected in your artwork.

Ready to render?

MATERIALS

Professional results can be obtained only by using the best-quality tools and materials. Even the most talented illustrators cannot produce optimum results with inferior supplies. Although it's tempting to save a bit of money, the quality of your artwork will suffer if certain compromises are made.

PAPER: To begin rendering, you will need good quality marker paper or vellum made specifically for markers. "Nonbleed" or "bleed-proof" papers are usually the best choice for clean, brilliant results. These papers are treated on the back so the marker solvent will not flow through to the underlying pages of the pad. Moreover, the continual flow (bleed) of marker tone is reduced and controlled on these surfaces. When copying an original drawing, both paper and vellum are ideal for running through a photocopier. Semitransparent vellum is especially good for tracing architectural and interior underdrawings, because colors can be blended more easily and both the front and back surfaces can be used for rendering. Tracing paper is invaluable for preliminary work.

MARKERS: Alcohol-based markers may be applied to both original and photocopied images. These nontoxic markers usually come with two or three different types of nib.* Many brands are refillable when dry. When blending or intentionally smearing one color into another, methyl hydrate (denatured alcohol) is used. This technique will be discussed in further detail on page 58.

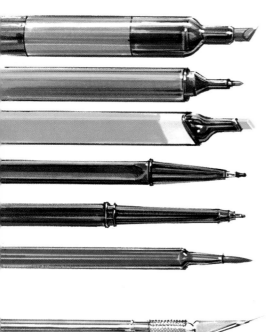

The predecessor to the alcohol-based marker is the xylene-based marker. These nonrefillable markers cannot be used on photocopies. They usually have only one tip and can be toxic if inhaled for a considerable period of time. Xylene-based markers have two important advantages over over alcohol-based markers: (1) they last somewhat longer before going dry, and (2) their colors are generally more brilliant.

Whichever type you choose, ensure that your working environment is well ventilated. A facial mask to screen chemical fumes is also a good idea.

Colors Needed**

- Full tonal range of each primary color: blue, yellow, and red
- Cool gray tones: #1 (gray 10%), #3 (gray 30%), #5 (gray 50%), #7 (gray 70%), #9 (gray 90%), and black
- Water-based fine-tip markers in the following colors: medium gray, light brown, blue, red, yellow, and black
- A nylon-tipped ultra-fine black marker is essential for lettering and adding details

* Markers are available with ultra-fine, fine, or broad nibs. Some brands provide more than one nib. If choosing a single-nibbed marker, opt for the more versatile broad nib.

** Additional colors will be suggested with each exercise.

KNIVES: A good quality scalpel or art knife is needed. Make sure the blade is replaceable; once the cutting edge becomes dull, the blade is useless and may ruin the paper. Remember to replace the blade often!

BRUSHES: A fine-tip red sable or half-synthetic/half-sable brush is great for adding details and highlights. A #0 or #1 brush should suffice. Keep a water container near-by to clean brushes or dilute paint when needed.

PENCILS/COLORED PENCILS/ERASER: A 2H pencil is ideal for preliminary drawings on tracing paper. Wax-based "pencil-crayons" can be used to highlight and model the rendering afterwards. A hard gum eraser is used to delete both pencil and pencil-crayon imperfections.

TAPE: White paper tape about 1/2- to 1-inch wide is good for general mounting of artwork; its low-tack sur-face allows for repositioning. Transparent tape is also recommended for final masking and repairs.

PAINT: Water-based gouache or tempera is good for highlights and special effects. Black, white, and the three primary colors (red, yellow, and blue) will suffice. For optimum results, however, bleed-proof opaque white watercolor is effective for adding highlights and for stopping water-based marker col-ors from seeping through the paint.

STRAIGHTEDGES/TEMPLATES: Plastic rulers, set squares, T squares, sweeps, ellipse guides, and French curves are very helpful to attain smooth or sharp lines. Note: When marker solvent comes in contact with the plastic edges of this equipment, the equipment may deteriorate if it isn't cleaned immediately. When cleaning your tools, use a mild, nonabrasive household detergent or rubber cement thinner.

WORK AREA: Be sure to choose a sturdy working surface, preferably at an angle at which you don't have to look down all the time. Try to main-tain a straight back and good posture habits. Your concentration level will benefit, and you will be able to ren-der for much longer periods of time.

RECOMMENDED APPLICATION

In this section, the fundamental base of marker rendering will be explored—the marker stroke. Two basic strokes that professionals use include the "venetian blind" technique and the smooth, quick "side-to-side" technique.

Once a preferred technique is established, ensure that the bottom edge of the broad nib makes full contact with the paper. Later, you may want to try altering the position of the marker in your hands. Experimentation reveals that the nib is capable of producing lines of varying degrees of thickness.

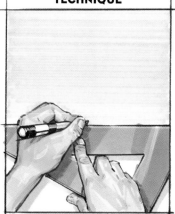

VENETIAN BLIND TECHNIQUE

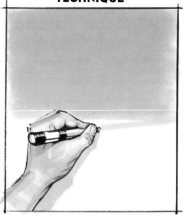

SIDE-TO-SIDE TECHNIQUE

For the **venetian blind technique**, simply place the edge of the marker against a T square, ruler, or set square, and then pull the marker from one side of the paper to the other, using the straight edge as a guide. Slightly overlap each horizontal line with the next. Make certain the surface of the straightedge is clean; otherwise, the marker will pick up any dirt or color and create a "muddy" streak.

The **side-to-side technique** is totally freehand and is sometimes referred to as "wet-in-wet." For this technique, quickly apply marker tone from one side of an area to the other. Render in one section until the paper is saturated. The paper surface should still be wet as you proceed down the page with the quick, side-to-side motion. Continue the motion until smooth coverage is attained.

For either method, you may want to mask off a rectangle or square (4–6 inches wide) with white paper tape before you start. Once the technique is successfully rendered, remove the tape. The edges of color should have a clean, even finish. You will find both techniques applicable for the exercises in this book.

MULTICOLOR GRADATION COMPARISON

Below are the results of the venetian blind technique (left) and the side-to-side technique (right). Notice the rough, graphic gradation of the venetian blind method and the smooth gradation of the side-to-side method.

These examples demonstrate an important rule of rendering: **Always put the lightest color on paper first and then overlap with darker colors.** While the marker color is still wet on the paper or vellum surface, quickly change to a darker color and blend. Continue with darker and darker colors until a smooth gradation is achieved. Practice this exercise until you're satisfied with the results. Refer to page 58 under "Methyl Hydrate and Solvents" for helpful hints regarding gradation.

When one color has dried completely and then an additional color is layered on top, the resulting tonal value is much more intense and graphic.

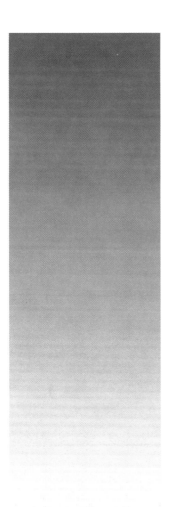 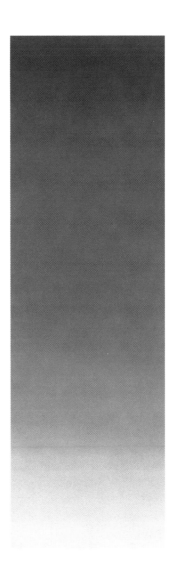

Exercise #1
RENDERING A CUBE IN GRAY TONES

TOOLS NEEDED
- Gray tone markers 10%, 30%, 50%, 70%, 90%, and black
- Water-based fine-tip gray marker
- Black and white pencil-crayons
- Fine-tip sable brush (#1)
- Opaque white watercolor paint

Outline the basic shape of the cube, including the shadow, with a fine-tip gray marker. Refrain from making a black outline at this point; otherwise, the rendering may appear cartoonish.

Assuming the light source is coming from the top left, the top of the cube should be the lightest area. Render this area with gray 10%.

Now apply gray 30% to the left surface of the cube and gray 50% to the right surface.

Incorporate additional tone (gray 70% and 90%) on the outside of the cube to add dimension. Finally, render the shadow in black. Add detailing with black and white pencil-crayons to sharpen the edges of the cube. Use opaque white paint for highlights or "farkles."

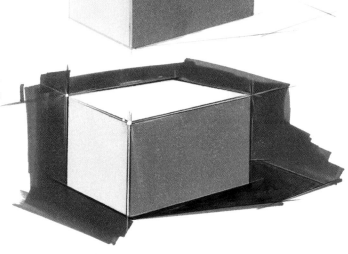

WOOD

- Fine-tip markers: brown, yellow 0%, light brown, brown, and any color such as "wood," "umber," or "oak"
- White and black pencil-crayons

Applying the same light source as with the gray cube, begin by applying the lightest tone, yellow 0%. Then add dark tones to the darker surfaces. Hint: A slightly dry marker can be advantageous for this subject, because the resulting streaky effect will enhance the look of wood grain. Apply wood detailing with a fine-tip brown marker. Use a white pencil-crayon to add highlights and a black pencil-crayon for sharpening the edges.

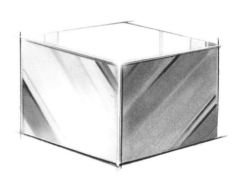

CHROME

- Markers: cream, light blue, cool gray 10%, 30%, 50%, 70%, and black
- Black and white pencil-crayons
- Opaque white watercolor paint

Apply streaks of light blue on all sides; then continue as in the exercise on page 8. When the gray marker tone is dry, go over it a second time with streaks of the same tone to intensify reflected shadows. Use black and white pencil-crayons for detailing and sharpening edges. Highlight the corner in the foreground with white paint.

GLASS

- Markers: cool gray 10%, 30%, 50%, 70%, 90%, and light blue-green
- Black and white pencil-crayons
- Opaque white watercolor paint

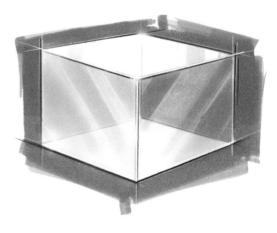

Assume all tones and colors behind a glass surface become less intense and lighter in value. Therefore, if there is a 70% cool gray background, it would appear as a 50% cool gray when placed behind glass. The more glass surfaces there are—and depending on their position respective to the light source—the lighter the background would appear. Render a gray cube as explained on page 8. Then add streaks of light blue-green to the corners to represent shadows. When dry, apply the same tone on each glass plane to darken. Add white pencil-crayon for highlights and black to define the edges of the glass cube. Add a white "farkle" on the top corner in the foreground to make the entire cube appear highly reflective.

HOW TO RENDER CYLINDERS, CONES, AND SPHERES

An invaluable rendering lesson is derived from the construction principles of the cylinder, cone, and sphere. A circle template (for the sphere) and an ellipse template (for the cone and cylinder) will significantly increase the accuracy of your drawings.

The following two pages explain how light and shadow fall on each shape. This procedure can be applied to many natural and man-made objects. For example, a soda pop can, a pipe, a tree trunk, arms, fingers, and legs—all can be considered cylinders for drawing purposes; a funnel, a spout, and even a mountain can be described as cones; and some examples of spheres are a baseball, eyeballs, and foods such as grapefruit, oranges, and berries.

It's an excellent idea to examine objects more closely and learn to simplify them as basic shapes. Observe their textures, highlights, shadows, and reflective qualities.

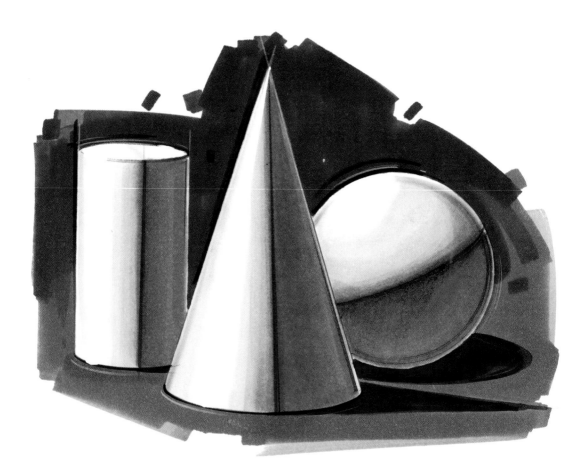

SHADOWS

Throughout this book, one light source will be used with each exercise. Observing the shapes from an overhead view allows us to see how shadows are cast onto the ground surface when the light is coming from above. The key element to remember is that the placement of the shadow is always at a 180° angle to the light source. In other words, the shadow appears on the opposite side of the light source.

OVERHEAD VIEW

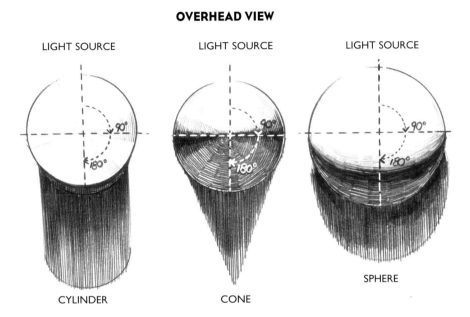

LIGHT SOURCE LIGHT SOURCE LIGHT SOURCE

SPHERE

CYLINDER CONE

Realistically, most renderings will be done from a three-quarter view. Therefore, it is essential to know how to apply the proper shadow angle from any view (reference may not always be at hand). Referring to the examples below, note where the shadow lies in accordance with the direction of the light source. The heavy black lines drawn on all three shapes indicate where the darkest part of the shadow lies. (See page 12.)

THREE-QUARTER VIEW

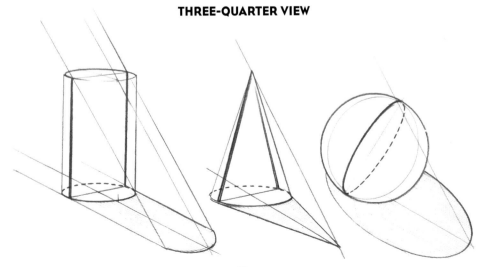

THE IMPORTANCE OF REFLECTIVE LIGHT AND WHY IT OCCURS

In reference to shapes, a trick that artists use to enhance dimension and realism is that of reflective light. Reflective light occurs when rays from the original light source bounce off the ground or other surroundings and illuminate the shadowed side of the object.

When an object receives a strong source of light from one side and a minor reflective source from the other, the surface that isn't receiving any light at all is the darkest area. Another way to envision this is to simply render the darkest values at a 90° angle to the brightest side of the subject.

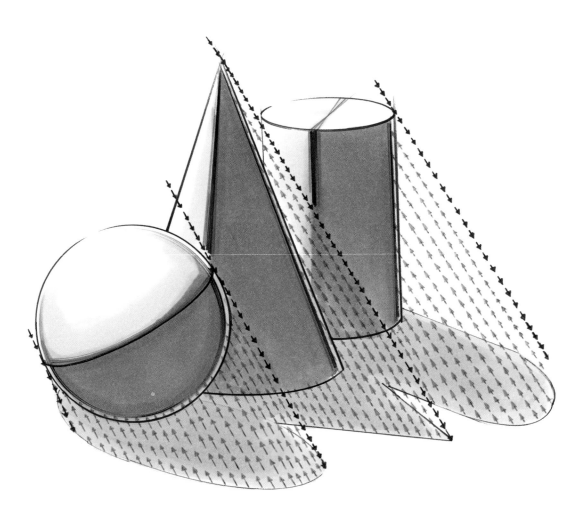

Exercise #2
CYLINDER, CONE, AND SPHERE

Before any rendering is attempted, it is highly recommended that an accurate linear drawing of the three objects and their respective shadows be worked out on tracing paper. Remember, the shadow is at a 180° angle to the light source. Again, the importance of ellipse and oval templates cannot be stressed strongly enough. If an object looks out of proportion, it probably is. Keep retracing the shapes until you are satisfied.

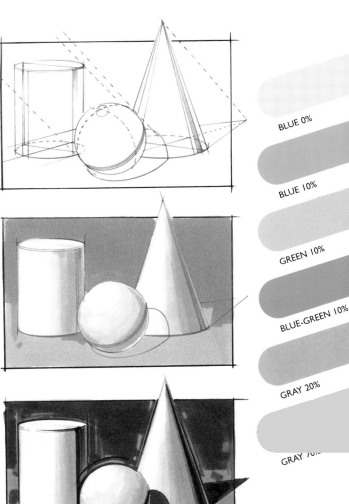

Using a fine-tip light gray marker, carefully trace the rough work from the tracing paper onto vellum or marker paper.

BLUE 0%

BLUE 10%

Begin with the lightest marker, and, while the ink is still wet, progress to the darker value. This will create a smooth gradation in tone. Note that the dark tones in the background compared with the bright highlights of the cylinder, cone, and sphere creates an important element of contrast.

GREEN 10%

BLUE-GREEN 10%

GRAY 20%

Use black and white pencil-crayons to help delineate the forms and shadows. To finish, paint a white highlight on each object to represent the brightest point.

GRAY 70%

HOW TO MAKE INVISIBLE REPAIRS
TO YOUR DRAWINGS

The following technique, known at the "miter" method, is extremely useful and forgiving to every renderer who has ever made a mistake and, subsequently, a correction, to his or her artwork.

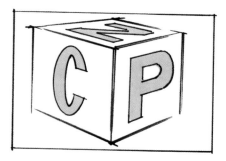

Assume the cube on the left has been approved, except for the letter "C." The client now wants the letter "A" in its place.

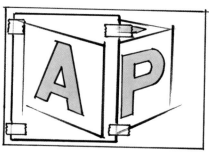

Instead of re-rendering the entire drawing, simply make the specified revision on a patch of paper or vellum (matching the original surface) and tape it over the area to be altered. (Repositionable paper tape provides the best results.)

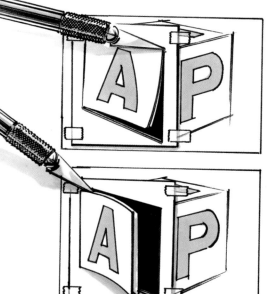

Now use a sharp art knife or scalpel to cut through both surface layers. (A metal ruler is ideal for guiding the blade.)

Notice that only three sides of the square are cut at this point. Do not cut the fourth side.

As an extra precaution to ensure that the new patch will be in the proper place, completely cover the cut areas of both layers with transparent tape.

Turn the artwork over. Then, using light pressure with the knife, cut the remaining side of the original square, being careful not to cut into the new patch. The side of the cube with the "C" on it may be discarded.

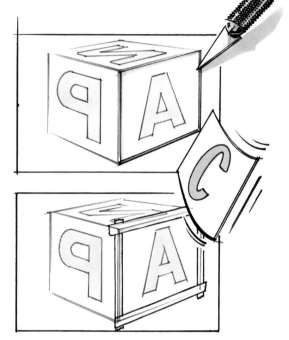

Finally, turn the artwork over again, and, once more, with little pressure on the knife, cut the last side of the patch. By using the back end of the scalpel or a burnisher and rubbing the cut area where the patch meets the original surface, the mending becomes nearly invisible.

This technique may sound more complicated than it really is. With a little practice, any mistake can become virtually invisible in no time at all.

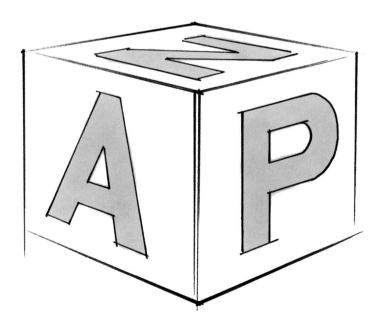

LETTERING—WHY IT IS SO IMPORTANT

Unlike the layout artist or designer of yesteryear, today's renderer can actually work in conjunction with the capabilities of the computer. The high-quality output from a computer printer has replaced hand-rendered type in many instances. The computer's version, however, is exactly that—high quality, with no interpretive or artistic quality. Therefore, it is still essential to know how to letter as proficiently as possible.

The form of lettering used most often (and the easiest) is the double-stroke method. This is done by drawing two parallel strokes to represent the thick part of the letters and one stroke to represent the thinner part.

First use a T square to lightly draw a series of three horizontal pencil guidelines on your paper. Uppercase (capital) letters will touch the top and bottom guidelines, and the lowercase letters fit between the middle and bottom lines, as shown below. The pencil guidelines will greatly improve readability and ensure that the words are drawn straight, from left to right.

When drawing the letters, all vertical strokes should be parallel to each other. When drawing rounded letters, such as C, G, J, O, Q, S, and U, the top and bottom should extend slightly beyond the guidelines; otherwise, these letters will appear too small for the rest of the alphabet.

Below are examples of double-stroke lettering for serif and sans serif type styles:

DOUBLE-STROKE — SERIF

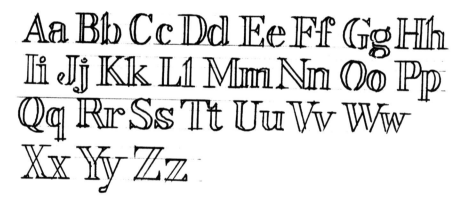

DOUBLE-STROKE — SANS SERIF

Letters roughly one inch or more in height should be traced from printed reference of a particular style. Accuracy is important, but keep in mind that rendered type should look rendered. The distinct effect of a rendered style is something a computer is incapable of generating. If letters are to be filled in solid, retain some of the white of the paper or vellum.

"Greeking" copy refers to the graphic indication of a body of copy in which individual words are unknown for the time being, but the result gives the essence of a sentence or paragraph. There are many ways to represent greeked copy. Below are three different examples: horizontal lines, horizontal lines with a scribble effect, and horizontal lines with "greek" or illegible words. Copy may be indicated in various ways, but one of these methods can be employed in most situations calling for the use of blocked type.

Exercise #3
WINE BOTTLE

Now it is time to use the basic rendering techniques to transform fundamental shapes into actual objects. The following exercise requires reference for a wine bottle and glass.

Before starting the initial drawing, notice how the objects can be broken down into simple shapes. For example, the wine bottle resembles a cylinder, and the stem of the glass resembles an elongated cone. Whether you choose to render the bottle shown in this example or one of your own choice, it is essential to have an accurate pencil drawing on tracing paper before any marker rendering is begun. Once your sketch is completed and appears proportional, move on to the final color rendering.

Note: The bottle has a highly reflective surface; however, the paper label has a matte finish and is much less reflective.

Using a light gray marker, copy the wine bottle and glass onto vellum or marker paper. Then begin rendering with the lightest tone of marker. For the wine glass and the area of the bottle where the wine is visible, apply a base coat with a light yellow-green. Once this dries, add a second application to provide a shadow streak on the glass. Use light cool grays to represent the stem and bottom of the glass.

For the label of the bottle, apply the lightest gray tone. Then, while still wet, blend in darker grays. Don't forget to retain reflective light on the dark side of the bottle.

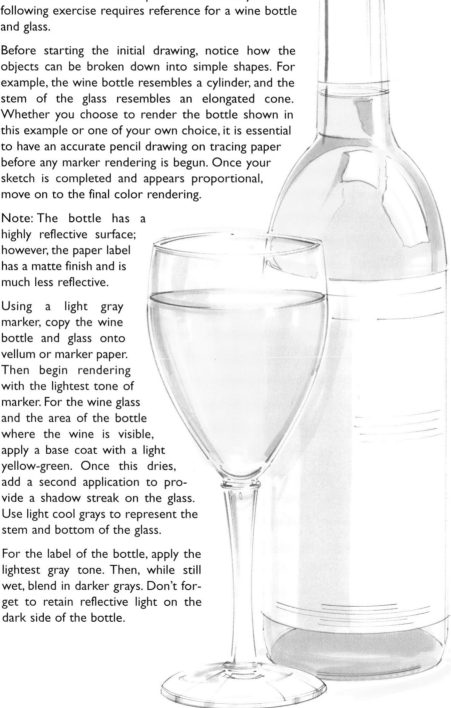

YELLOW 0%

GRAY 10%

GRAY 50%

GRAY 70%

BLACK

YELLOW-GREEN

LEAF GREEN

BLUE

RED

BLUE 10%

At this point, examine where the shadows of leaf green, gray 50%, and gray 70% are placed vertically, and ensure that any shadow on the label appears vertically on the bottle as well.

Use a background of blue 10%, blue, and gray 50% to create a contrast between the bottle and the highlight on the glass. This technique makes both objects "pop" into the foreground.

The detail of the logo and the lettering on the label require time and a keen eye. Greek in any extremely small or insignificant type (see page 17). Lay in the bolder type with light gray, and then go over the lines with a fine-tip black marker.

Use a black marker to add final touches to the bottle—for example, to accent the shadows, making it appear more reflective.

Use nonbleed opaque white watercolor paint to enhance the rim of the glass and parts of the bottle.

Finally, use black and white pencil-crayons for subtle shadowing, detailing, and defining edges.

DRY WHITE WINE
VIN BLANC SEC

RENDERING PEOPLE

When rendering architectural, interior, and advertising images, the addition of people can enliven a sometimes rigid composition. The human element can accentuate style or mood, depict a marketable age group, and direct the viewer's eye to the prime focus of the rendering. Admittedly, there are no shortcuts for rendering people convincingly. Constant practice in drawing live subjects is the best way to strengthen this ability.

The average human is 7.5 heads high, although many artists will illustrate a body at a height of 8 heads. In science fiction and cartoon drawings, the artist may not only incorporate 8 or 9 heads for human height, but also exaggerate muscles and action—a form of artistic license known as "heroic proportions." In fashion rendering, the distortion of figures can range from 9 to 11 heads. The elegance and dynamic embodiment of this subject matter is usually captured in a much more interpretive, loose style. (This will be covered in detail on pages 26 and 27.)

With certain time constraints, it is sometimes necessary to trace existing photos. Project deadlines often lead to the notion that a renderer is only as good as his or her reference, or "swipe," file.

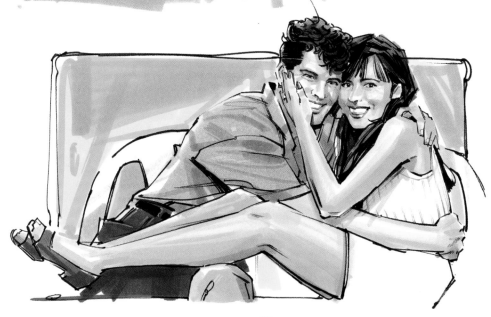

20

When starting a swipe file, fashion, sports, and news magazines are good sources. Mail order catalogs also contain excellent reference shots. An extensive file, built up over time, should consist of babies, children, teenagers, young and middle-aged adults, senior citizens, couples, families, and various costumes and wardrobes.

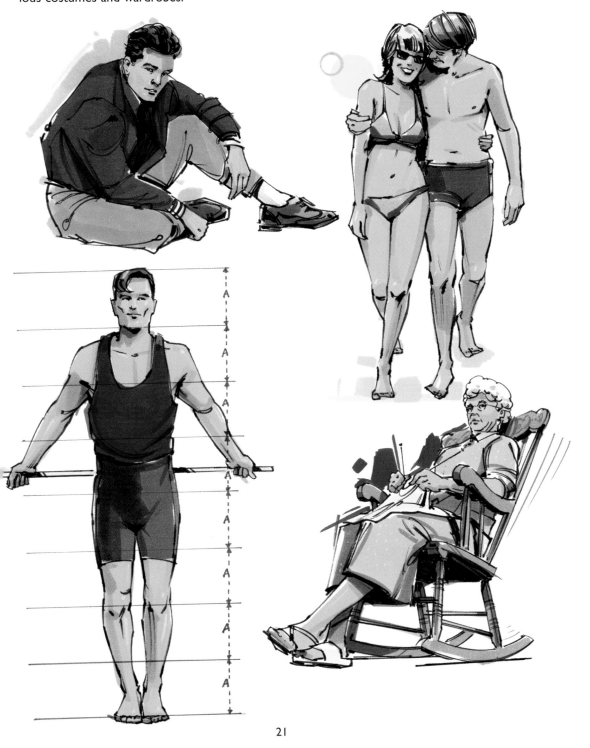

MEN'S FACES

Eventually, you will discover that a swipe file offers only so many reference angles. In the event that you are working on a storyboard or an animatic, it is almost certain that basic drawing knowledge of the face will be required.

Using pencil, lightly draw an oval. Then draw a horizontal guideline at the mid-point, dividing the oval in half. Divide the bottom half and then divide again. Now draw a line to indicate the vertical mid-point. Note that the drawing to the right denotes these lines, as well as the parts of the face. Particularly observe the juxtaposition of the features, such as the eyes, and the distance between them.

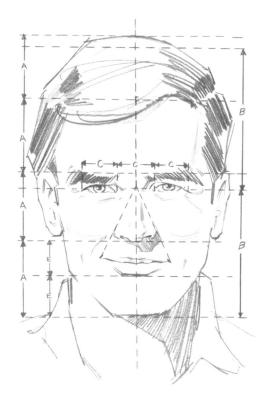

To render a Caucasian subject, trace the face with a fine-tip black marker. Then use a pale flesh tone marker to cover the entire face. (Experiment with various hues to render other skin types.) Retain the white of the paper for the highlight on the nose. Use a darker flesh tone under the eyes, nose, bottom lip, jaw, and the shadowed side of the face. Apply gray 10% to the beard area. Finish the darkest areas of the face with a dark pink or cherry marker. In this case, light golden brown was used for the base color of the hair, with dark brown added for contrast and dimension. Once again, use a white pencil-crayon and white paint to highlight key areas.

Step back and observe your work occasionally to gauge your proportions and to avoid overworking certain areas. The economy of line is noteworthy, particularly in reference to the eyes, nose, and teeth, so try to keep the rendering strokes to a minimum. Experience will prove that simplifying a drawing produces the best results.

WOMEN'S FACES

The greatest difference between men's and women's faces is in the shadowing and line treatment.

The initial composition of a woman's face is the same as that of a man's: the eyes, nose, and mouth are positioned identically. The eyelids of a woman, however, are generally more prominent, and the eyebrows are higher and thinner and possess a graceful curve. Eyelashes should be drawn as one smooth, thick line, becoming heavier at the outside corners. This is a good time to follow the popular adage "less is more." A common mistake is to draw each lash and every facial line and crease.

The lips are generally fuller and, again, a continuous smooth line is used to represent them. The nose should be small and tilted slightly upwards. A mere suggestion of nostrils will suffice. Finally, avoid drawing hairstyles that tend to lie flat.

Trace the face using a fine-tip black marker, and then apply light flesh color. Keep the shadows or dark tones to a minimum. The softer the face, the more feminine it will appear. Don't forget to add a small highlight of white paint on the focal point of the eye—the pupil. Use rubine red or process red for the lips to suggest lipstick. Make the upper lip darker because the light source is coming from above. Initially, the hair base should consist of a light tone, such as yellow ochre. Use a deep dark brown marker for the darkest sections of hair. Use colored pencil-crayons to help accentuate the face by imitating eye shadow and blush.

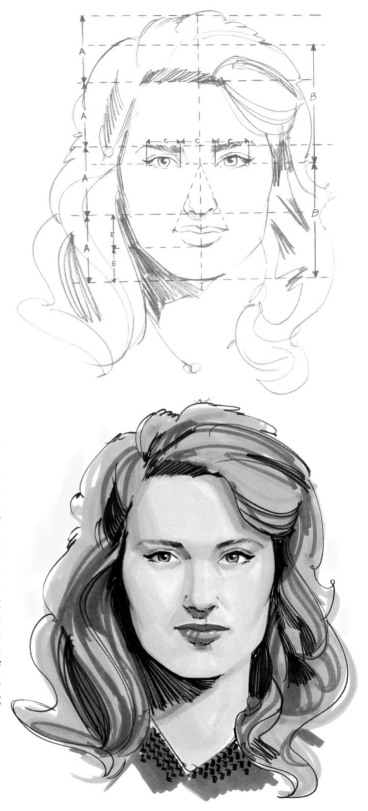

CHILDREN

In the fashion industry, as well as many other areas of advertising, children are strong selling tools. This means there is a substantial amount of work for the illustrator who can capture the unique characteristics of children.

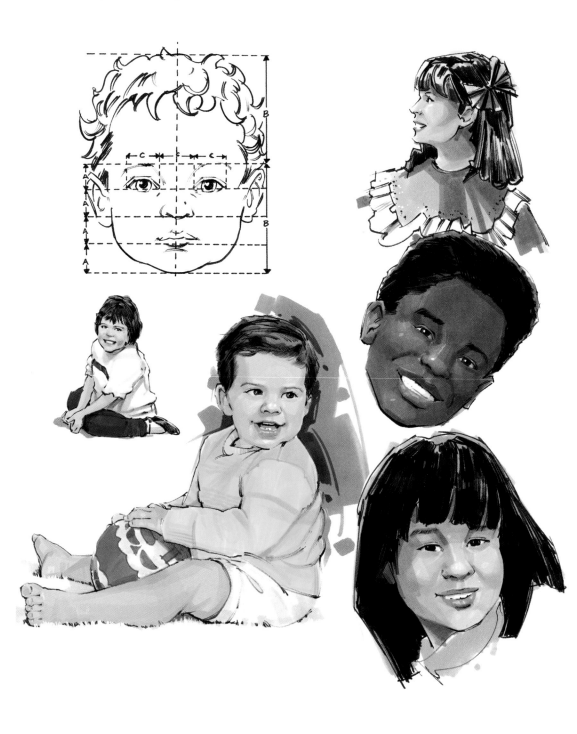

An important point to remember is that human body and facial proportions change constantly between birth and adulthood. For example, the visual center of a baby's body is around the navel, but, as the child approaches puberty, the central point shifts down to the pelvic region. Moreover, at age three, the body is 5 heads high; at age six, it is 6 heads high; and, at puberty, it is 7 heads high.

The eyes of an infant are set much lower than the horizontal midpoint of the head. As the child develops, the face gets longer, the eye level moves up, toward the midpoint, and the upper and lower jaws, as well as the nose, increase in size. A baby's eyeball is actually fully developed. It is simply the eyelids that widen as he or she grows older; this is why we see more white in the eyes of adults.

As when rendering women, it is important to work quickly to keep the paper wet and to more easily blend skin tones. The final image should look soft with a minimal amount of line work.

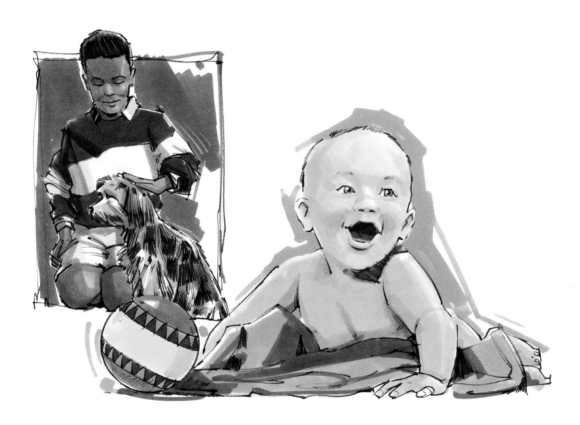

Exercise #4
FASHION

Marker rendering lends itself very well to fashion illustration. The fashion industry has often employed artists not only for creating the conceptual stages of design but also for illustrating runway models in motion.

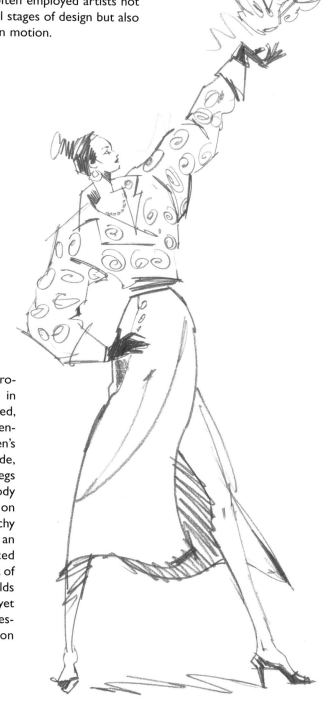

As mentioned previously, the proportions of the human figure in fashion are greatly exaggerated, with body height often being rendered 9 to 11 heads high. Men's shoulders are extraordinarily wide, and, with either gender, the legs constitute more than half the body length. The initial rough drawing on tracing paper should be sketchy with flowing lines. Whether it is an original drawing or one traced from a reference shot, treatment of movement creases and fabric folds should be indicated in a subtle yet direct manner, and the overall gesture should reflect the fashion statement and mood.

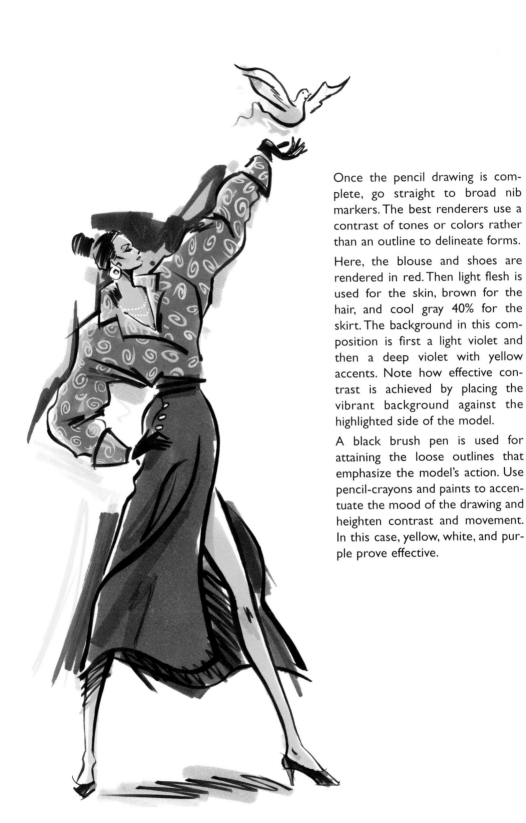

Once the pencil drawing is complete, go straight to broad nib markers. The best renderers use a contrast of tones or colors rather than an outline to delineate forms.

Here, the blouse and shoes are rendered in red. Then light flesh is used for the skin, brown for the hair, and cool gray 40% for the skirt. The background in this composition is first a light violet and then a deep violet with yellow accents. Note how effective contrast is achieved by placing the vibrant background against the highlighted side of the model.

A black brush pen is used for attaining the loose outlines that emphasize the model's action. Use pencil-crayons and paints to accentuate the mood of the drawing and heighten contrast and movement. In this case, yellow, white, and purple prove effective.

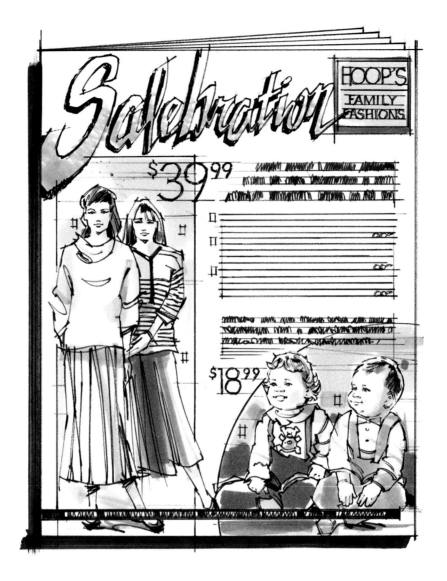

RETAIL LAYOUTS

They've filled our mailboxes for years, pushing the latest fashion, seasonal items, and sales. The bottom line is that retail catalogs, flyers, and newspaper and magazine ads are highly effective. Many artists find their first jobs designing and rendering such layouts. Although computer art programs have developed significantly over the past few years, there will always be a demand for artists who can create effective ads.

Because of deadlines, volume demand, and the nature of the business, it is essential to develop quick rendering skills—both in color and in black-and-white. It is a good idea to show your layout skills in your portfolio, especially when you are just starting out.

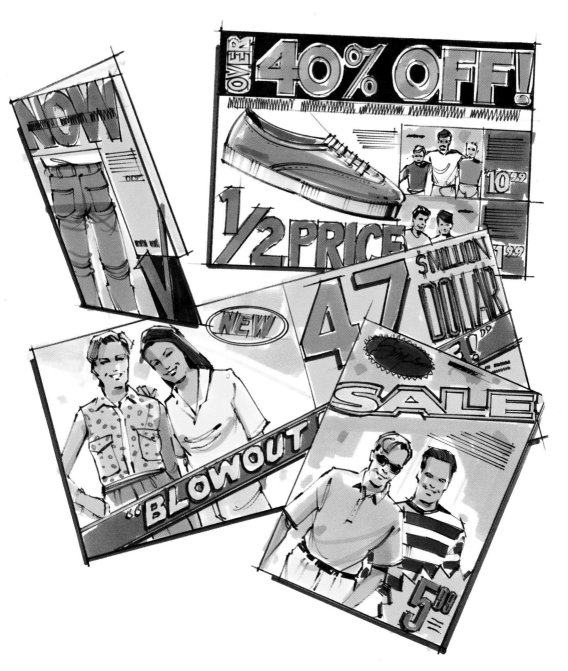

Although it is easier to copy an existing retail, newspaper, or magazine ad, it is better practice to create something new and exciting using the same elements. (For more portfolio tips, turn to page 63.)

Exercise #5
LANDSCAPES

Landscaped backgrounds are often used to complete a mood or set a scene.

A reference file is not complete without a viable background section. Consider landscape scenes from all around the world: rural, mountainous, beach, suburban, urban, tropical, arctic, agricultural, desert, and oceanic.

The reference shot used for this exercise was taken from a photograph of the North American Rocky Mountains. Depending on the composition required, the need to eliminate, add, or shift an element in the reference material may be necessary when transposing to the tracing paper sketch.

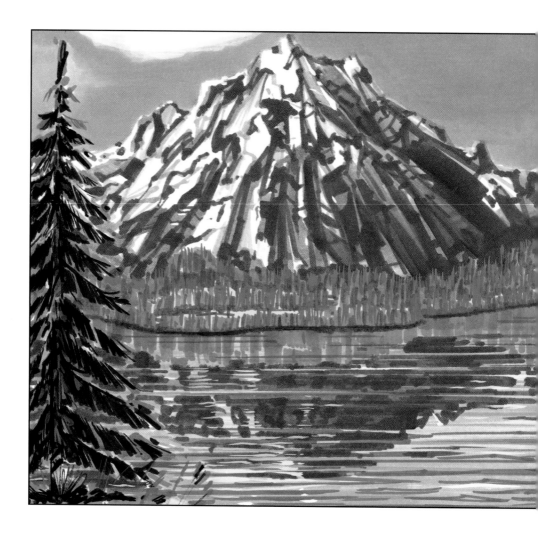

The colors used in this exercise are shown to the right and are not in any particular order. The same colors often have different names, depending on the manufacturer—and this can be frustrating! The best way to overcome this problem is to try to match the colors shown here on sample marker paper at the art store before you make the purchase. Not only will you be able to check the color, but you can also confirm whether the felt tip is saturated with ink. Sometimes improper shipping or other customers will inadvertently loosen the marker lid, leaving the tip exposed to air, evaporating the ink. Always ensure that new markers are in good working order, because many stores will not offer exchanges or refunds.

BLUE 0%

BLUE 20%

BLUE-GREEN

LIGHT VIOLET

YELLOW-GREEN 10%

LEAF GREEN

EMERALD GREEN

GRAY 20%

GRAY 60%

BLACK

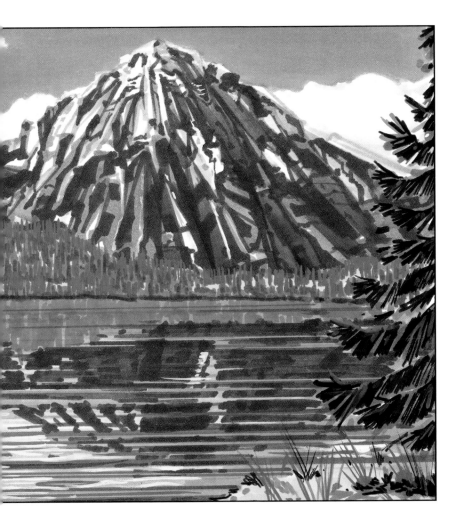

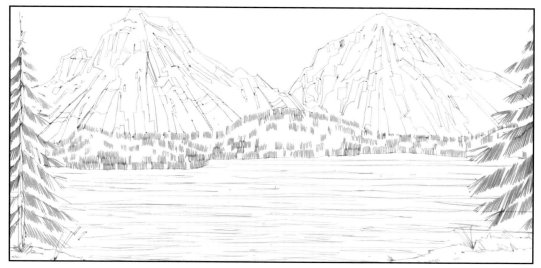

1. First, trace the complete scene onto marker vellum or layout paper using a fine-tip medium gray marker. Always ensure that the paper surface is clean, because nothing looks more unprofessional than dark smudges or specks in a light colored area. If there happens to be a marker smudge, it can sometimes be rubbed out with an eraser. If erasing is ineffective, it is best to start over.

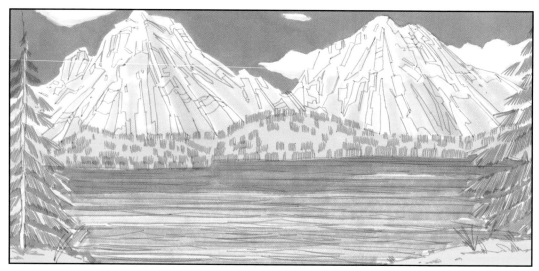

2. Render the lightest blues in the mountains, lake, and sky with blue 0% and blue 20% markers. Retain the white of the paper to form the clouds in the sky, the snow on the mountains, and the whitecaps and reflected highlights in the water. Use yellow-green 10% for the base of the clusters of background foliage.

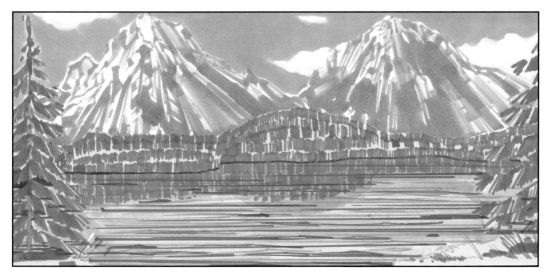

3. Now apply more detailing on the shaded side of the mountain with a light violet marker. Use cool gray 20% and cool gray 60% to complete the stone-like finish of the mountains. Mottle leaf green hue in the trees for definition and shadows. Apply yellow-green and leaf green in the water to indicate the reflection of the forest. Use blue-green marker in broad strokes to indicate the dark sides of the waves. With emerald green and black markers, embellish the richness of the trees.

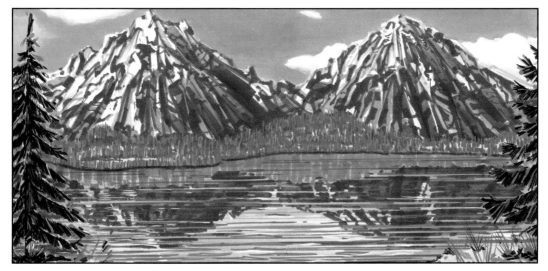

4. Use a black pencil-crayon or water-based fine-tip marker for the finishing touches in the foreground. Apply dark blue pencil-crayon or pastel to subtly darken the top of the sky, and then add bleed-proof white paint to the tips of a few waves. Finally, apply chartreuse paint to highlight the grass and trees.

Exercise #6
STILL LIFE

In advertising, the food and beverage industries are big business. Thus, there is a considerable demand for renderings that capture the freshness and appeal of these products, increasing the appetite of the consumer.

The subject matter of the following project is composed of meat, vegetables, bread, fruit, and a beverage. Notice that the meat appears freshly cooked, the fruits and vegetables look ripe and succulent, and the mug of frosty cold beer has "sweat" droplets running down the sides.

LIGHT VIOLET

SKY BLUE

BLUE-GREEN

LEAF GREEN

YELLOW-GREEN 10%

GRAY 10%

GRAY 20%

GRAY 60%

WARM GRAY 40%

BLACK

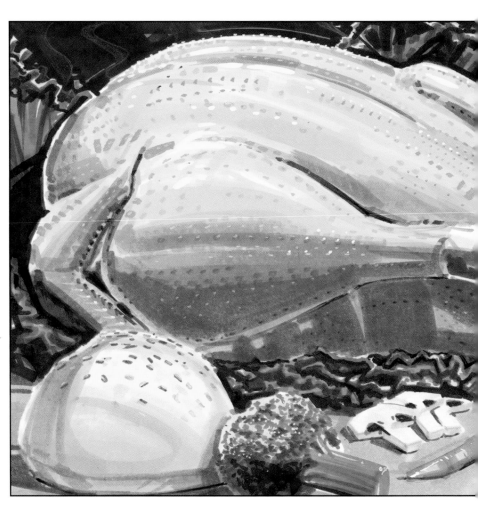

In general, these types of scenes should be well lit, because food and beverages look best when they are bright and colorful. Also, remember that cast shadows look more interesting when blended with a violet or purple.

The marker palette used for this project is shown on these two pages; the step-by-step instructions are on pages 36 and 37. You may not find these exact colors, but comparable markers are available. Your choice, of course, will depend on your subject matter.

POWDER PINK

RED

DARK RED

YELLOW 0%

AMBER

ORANGE

BROWN

DELTA BROWN

BROWN 10%

LIGHT BEIGE

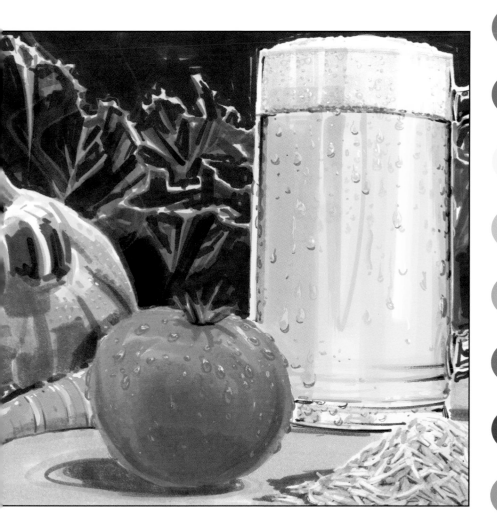

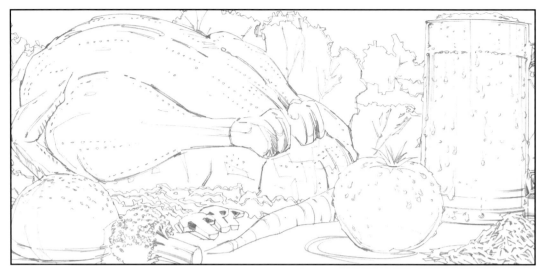

1. This is the original sketch used as a basis for the illustration. Make certain the composition, proportion, and shadows enhance each element of the still life illustration. Note: The actual size of this rendering is approximately 8″ x 16″.

BASE COLORS

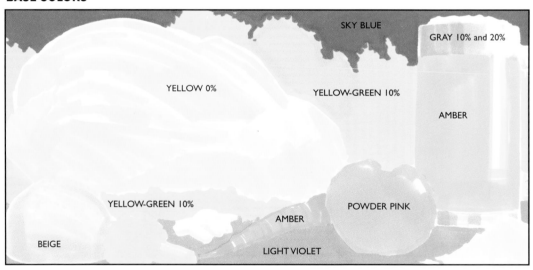

SKY BLUE

GRAY 10% and 20%

YELLOW 0%

YELLOW-GREEN 10%

AMBER

YELLOW-GREEN 10%

POWDER PINK

AMBER

BEIGE

LIGHT VIOLET

2. Fill in the general shapes with the colors indicated above. It is best to render the food in color without the use of outlines so the overall image will be more interpretive and less cartoon-like.

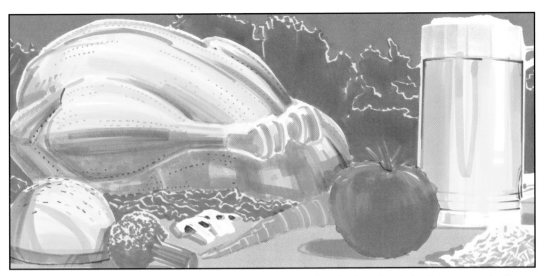

3. Next, add beige, brown 10%, dark red, and orange to the chicken. Apply leaf green to the broccoli and lettuce. Use cool gray 10%, warm gray 40%, and brown for the mushrooms. Add brown 10% to the bun, and provide detail in the seeds with a fine-tip light brown marker. Apply orange on the carrot and red on the tomato. Apply brown 10% to the shadow side of the beer. Use warm gray 40% for the grain pile, and place sky blue on top of the light violet to represent shadows.

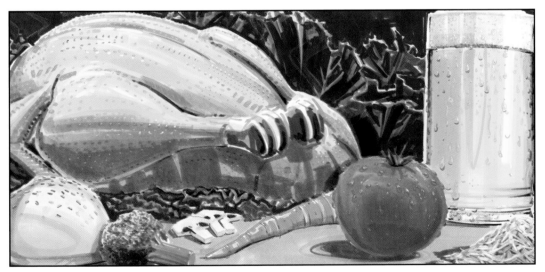

4. Bring out the detailing of the chicken with brown and delta brown. Apply blue-green to the broccoli and lettuce; add further depth with black. Place gray 60% on top of the sky blue background. Enhance the carrot with dark red. Use red to go over the tomato again; then, while still wet, apply dark red to create depth. Add delta brown shadows on the sides of the beer mug. Draw in the details of the grain pile with a fine-tip medium gray marker. Use cool gray 60% for the shadows on the ground. Use cream paint to reinforce details and highlights and colored pencil-crayons for the droplets. Finally, use white pencil-crayon or pastel to fortify the effect of steam rising from the hot chicken.

STORYBOARDS

Television and movie theater advertisements are powerful media for delivering a message to the public; thus, they can be quite lucrative.

An extremely effective and popular method of illustrating a proposal for these media is to create a scaled-down visual representation of the idea. The message, expressed in a frame-by-frame sequence, is called a "storyboard."

Tight deadlines are common in storyboard advertising, often prompting an artist to rely on his or her memory for suitable reference. Again, the reality of such time constraints emphasizes the importance of a well-stocked reference file.

The demonstration on the following pages illustrates a realistic progression of a hypothetical television commercial for a new cereal for kids—"Bob-O."

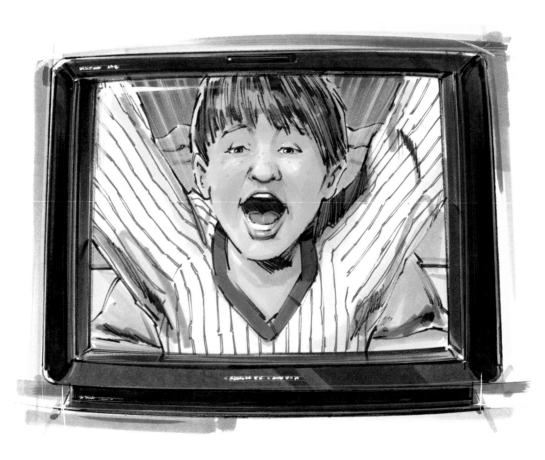

INTRODUCTION TO "BOB-O" CEREAL

During the initial briefing, the art director calls on the illustrator to create some pencil linears from the script. The artist's visual ideas are roughed out in a quick, sketchy manner to match the written message. These preliminary drawings are called thumbnail sketches.

The rough images to the right are typical of the type provided in such a meeting. The first setting of the "Bob-O" commercial reveals an extreme close-up shot of a 10-year-old boy as he wakes up in the morning. The next sequence is a mid-shot of his pajama-clad parents as they stretch in their bed. The third frame shows a cut back to the close-up of the boy looking into the camera. The fourth shot is routinely called a "beauty shot" of the package; then we see a shot of milk pouring onto the cereal. In the sixth frame, another close-up is used—the boy enjoying the cereal. Next, the boy hears his parents approaching and quickly empties the contents of the box into his bowl. In the next shot, he quietly sneaks out of the kitchen with a heaping bowl of "Bob-O" cereal. The final frame shows the parents looking puzzled as to the whereabouts of the cereal. Frequently, a line of type accompanies the final frame.

Note: To quote a price for a storyboard job, one would usually charge on a per-frame basis. The price would also be contingent upon frame size, black-and-white or color rendering, deadline, and, of course, the client's budget.

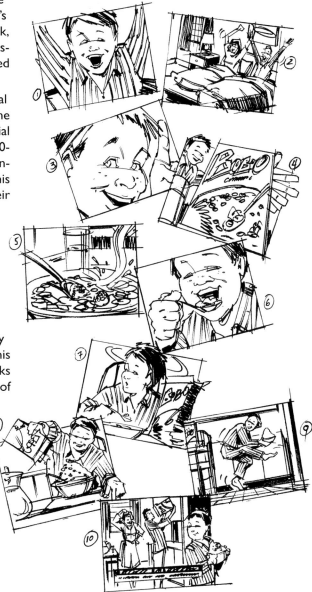

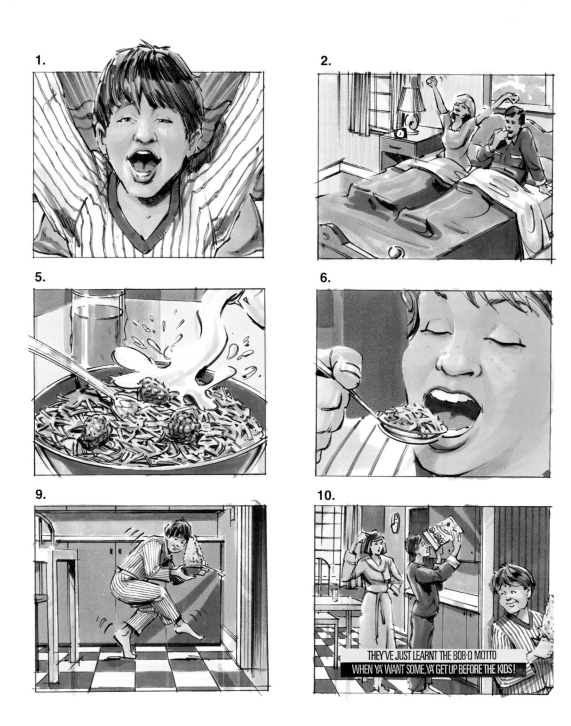

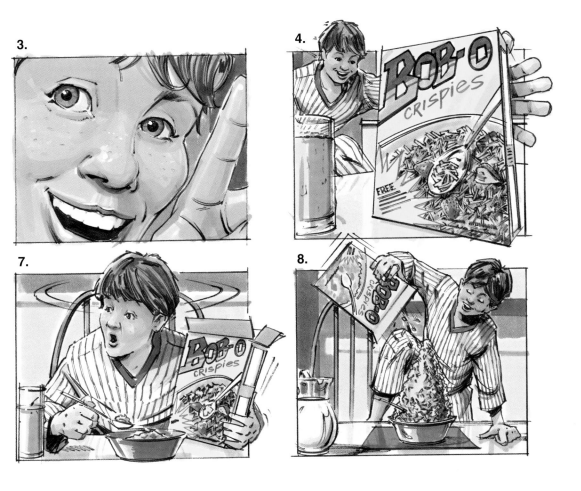

Here are the final 4" x 5" color frames. Prior to completion in color, the artist's original pencil sketches are shown to the art director and possibly to the client for comment or approval.

For those who are seeking work as a renderer in advertising, storyboard samples offer an impressive addition to a portfolio. Duplicate a commercial or, better yet, create an innovative storyboard with dynamic colors and camera angles. To create a positive outlook for your job search, be sure to choose frames that exhibit your rendering strengths, not your weaknesses.

"NEW YORK STYLE" STORYBOARDS

This unique and highly effective format is also called a flow board. It provides an option for presentation through the overlapping of frames to create a flow from start to finish. The size of the individual frame is usually directly proportional to its importance within the story.

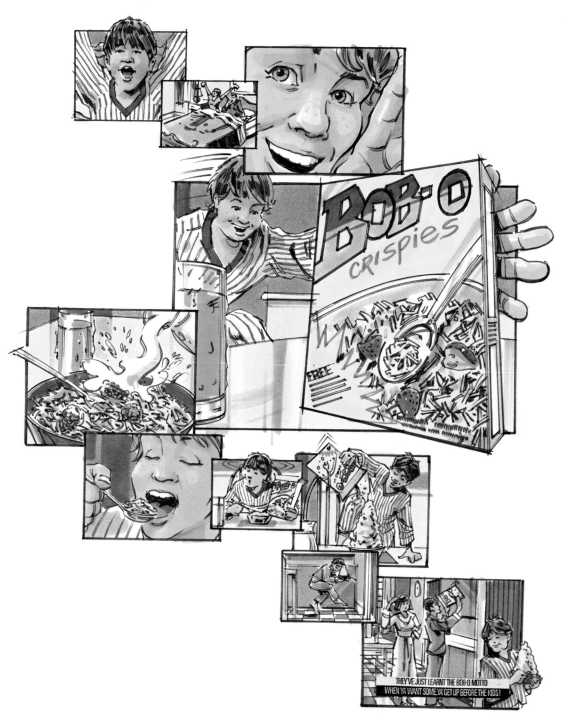

ANIMATICS

Upon approval of the storyboard by the client, an animatic is usually the next step prior to the final production of the commercial. An animatic is composed of a variety of rendered cutouts that are videotaped sequence by sequence, much like the steps in animation. Upon completion, the finished video gives the illusion of action and movement.

The background is usually rendered separately from essential foreground people or objects. Alternative gestures are individually rendered and then appropriately positioned while being videotaped or filmed frame by frame. In the next action sequence, another cutout is placed in position.

Below are two frames from an animatic. The automobile has an alternative position of the door with the man stepping out, as shown at the right. When videotaped and overlapped, the illusion of the door opening is created. When the cutouts of the other animatic are sequentially placed, the appearance of a talking spokesman is created.

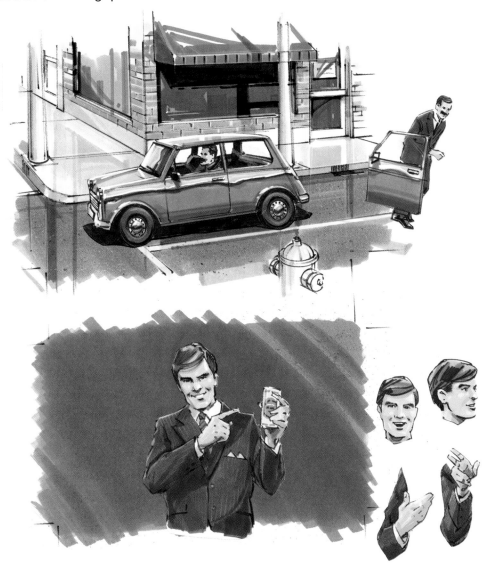

BLUE 10%

RED 10%

RED

GRAY 40%

GRAY 60%

BLACK

YELLOW

YELLOW-BROWN

YELLOW-GREEN 10%

Exercise #7
HIGH-REALISM RENDERING

When a larger budget is involved, a client may insist on seeing how an ad will appear prior to the expense of final production. In this case, the entire layout should appear as photographic as possible. The portable stereo on page 45 is rendered using the colors displayed here.

Attention to perspective and detail are crucial at the pencil stage, so ellipse guides, French curves, and a ruler are essential. Use a fine-tip black marker to outline the "boom box." Use a blue 10% marker to cover the complete object; make the marker tone extend past the outline of the object to create even coverage. Because the image will be cut out eventually, the extended color is of no concern.

Once the light blue has dried, apply cool gray 40% over it. Add cool gray 60% and black to provide and then deepen the mid to dark shadows. Use a yellow marker on the handle and control knobs and yellow-brown for shadowing. With fine-tip red and yellow-green 10% markers, indicate the illuminated display diodes.

To give the illusion of the speaker's metal protective cover, apply a section of continuous dot pattern from a dry transfer sheet on top of the speaker area.

Use white paint and a fine-tip brush for lettering and creating highlights. (If you're handy with an airbrush, use it for highlighting, but don't overdo it.) Try using a ruling pen for painting consistent straight lines such as edges and corners. Use a sharp white pencil-crayon for the subtle, graduated lines. Use light blue pencil-crayon against the shaded side to help define dimension and reflective light.

Finally, cut out the stereo with a scalpel, then mount it onto another background to create a clean, professional presentation.

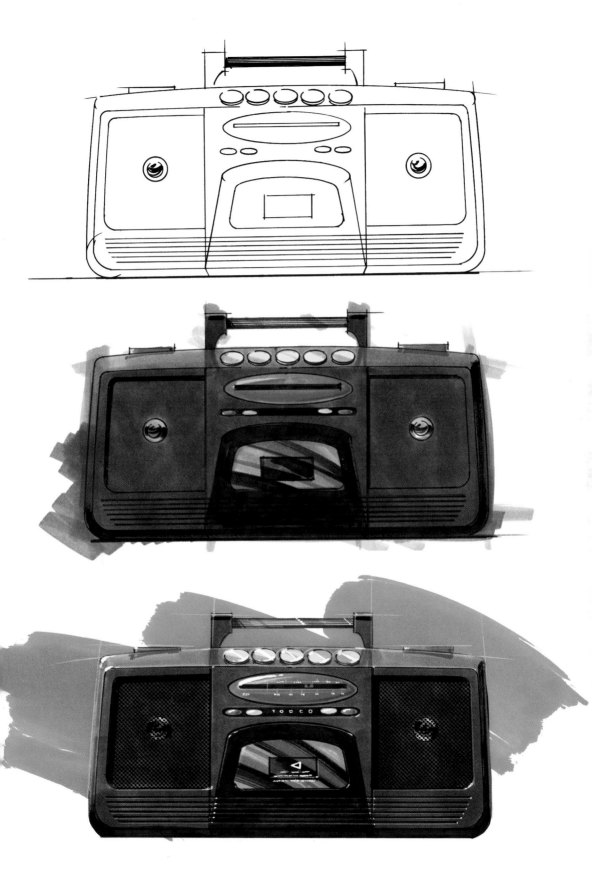

Exercise #8
AUTOMOBILES

It's no secret that the automobile industry spends millions of dollars on advertising. Therefore, there is a great demand for professional automobile renderers. If you have an interest in drawing cars, this exercise should appeal to you.

Like the human form, the car can be quite complex in shape and color; it is capable of evoking a variety of emotional responses. Also in keeping with the human form, correct perspective is imperative. We are so familiar with the common sight of the automobile that even the smallest aberration in drawn representation is apparent.

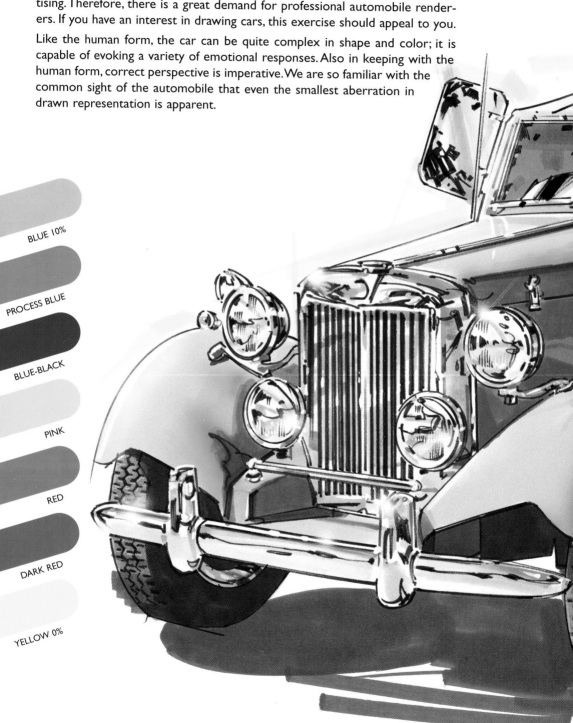

BLUE 10%

PROCESS BLUE

BLUE-BLACK

PINK

RED

DARK RED

YELLOW 0%

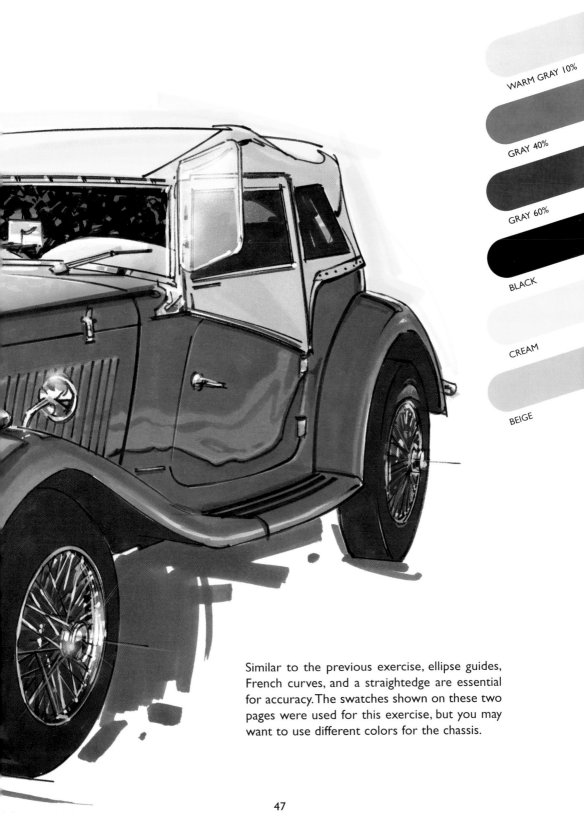

WARM GRAY 10%

GRAY 40%

GRAY 60%

BLACK

CREAM

BEIGE

Similar to the previous exercise, ellipse guides, French curves, and a straightedge are essential for accuracy. The swatches shown on these two pages were used for this exercise, but you may want to use different colors for the chassis.

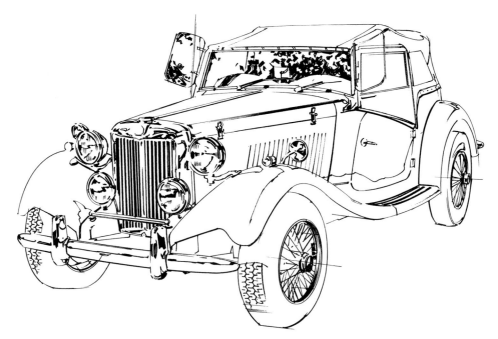

1. When seeking proper perspective, the accuracy of the initial pencil sketch is vital. Using the underdrawing, trace onto marker paper or vellum with a fine-tip black marker. Overlap the lines slightly to create flow and decrease the rigidity of the drawing.

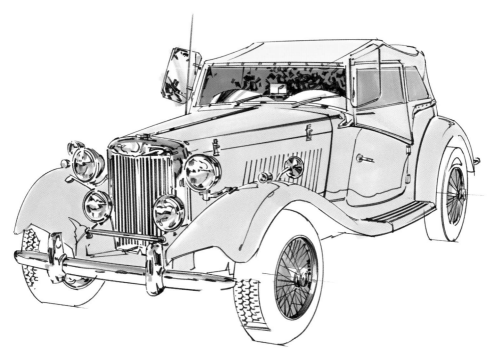

2. Assuming the car is red, lay in pink marker on the brightest areas: the hood, roof, and trunk. Add blue 10% and process blue for the chrome and windows. For the ragtop, apply yellow 0%, followed by cream, and then warm gray 10%.

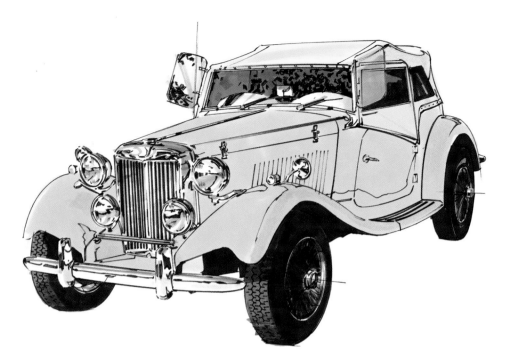

3. Define the wheels and the grill with cool gray 40%. Once dry, add cool gray 60% and then black. Lay in some blue 10% over the pink in the shadow areas, then add beige on the shaded side of the ragtop.

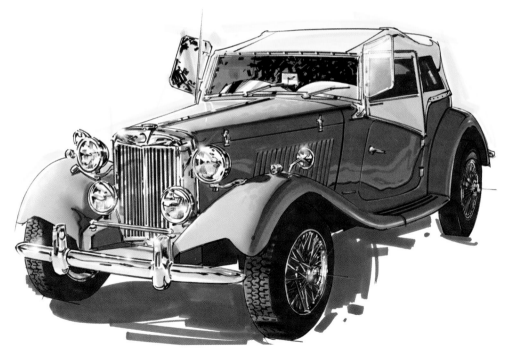

4. Now for the finishing touches: use red marker for the midtone, dark red for the shadow. Apply blue-black tone underneath the car to create a suitable contrast for a "loose shadow." Add cream marker sparingly to the top to warm the overall effect. Apply light blue and white paint to high-light key areas.

Exercise #9
INTERIOR RENDERINGS

PERSPECTIVE, PERSPECTIVE, PERSPECTIVE!

To many artists, perspective means preliminary drudgery—but the fact of the matter remains: it is indispensable for constructive illustration. As every design student knows, a firm understanding of perspective principles is essential for executing accurate drawings. The three basic types of perspective have been explained here in a concise, easy-to-follow manner. The exercise begins on page 52.

Note: For immediate purposes, the realm of perspective theory has been oversimplified, and, even though a basis has been provided to allow for these exercises, further instruction on the topic will undoubtedly be to your advantage. (See Walter Foster book *Perspective* by William Powell, #AL13.)

ONE-POINT PERSPECTIVE

Despite the considerable number of pieces of furniture in the drawing below, notice how all horizontal lines converge toward one point in the middle of the room. The eye level (or horizon) represents the artist's viewpoint of the scene. All vertical lines are parallel.

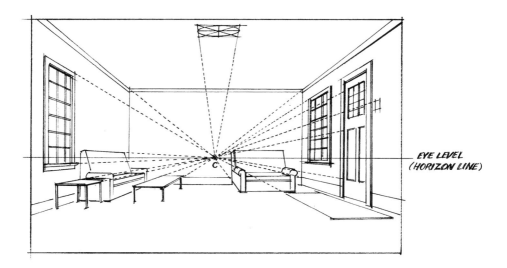

EYE LEVEL
(HORIZON LINE)

TWO-POINT PERSPECTIVE

This typical street scene uses two points on either side of the eye level. These are called the vanishing points. All horizontal lines within the drawing converge at one of the two vanishing points. Note, again, that all vertical lines remain parallel to one another.

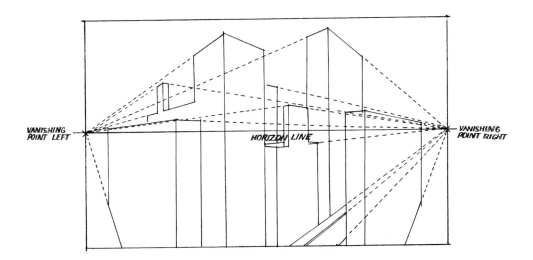

THREE-POINT PERSPECTIVE

Three-point perspective is used to create the essence of dynamic and "larger-than-life" scenes. Two vanishing points are established on either side of the eye level for the horizontal lines, as with two-point perspective, and a third vanishing point is placed arbitrarily far above or below. All vertical lines converge at this third point.

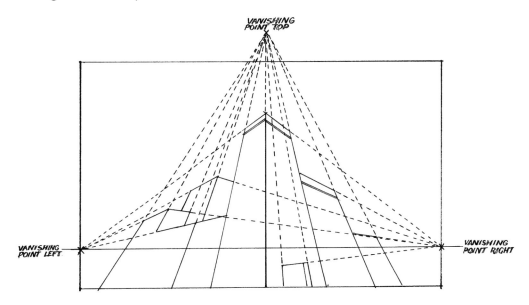

1. As in previous exercises, a linear drawing is required. Once the drawing is complete, transfer the image onto vellum or marker paper with a fine-tip black marker. Notice what happens to a circular shape when drawn in perspective: it becomes an oval or an ellipse. Just as a circle fits within the confines of a box, the shape of the same circle changes as the shape of the box changes in perspective.

To create a sketchy feel to your work, make the construction lines overlap slightly. With experimentation, a freehand style—that is, drawing and shading without the use of a straight edge—may feel more comfortable.

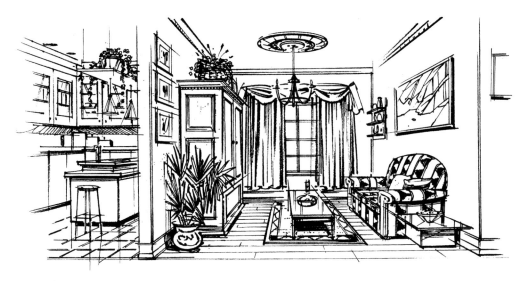

2. Determine the light source(s). What direction is the sun coming from? Are any interior lights on? If so, how many? When the tones are laid down, ensure that there is a color harmony in synchronization with the furniture and surroundings. You may want to study patterns and blends used by professional interior designers.

For this exercise, use yellow 0% plus blue 0% to cover the window and beige for the kitchen cupboards and the armoire. Use yellow ochre for the kitchen floor and chartreuse for the plants. Place warm gray 10% on the foreground walls.

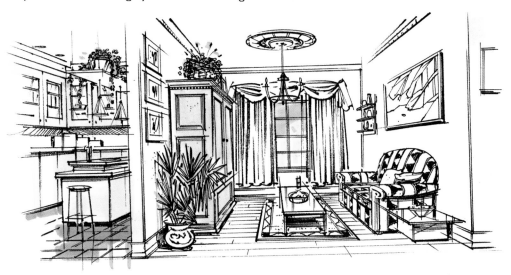

3. Use yellow 10% extensively around the walls and blue 10% for the couch. Use brown 10% for the shaded area of the armoire (the side closest to the viewer). Notice how certain areas are left untouched on the floor to represent bright light reflections.

In architectural or interior design renderings, it is not unusual to leave certain areas absent of color with simply the initial line drawing present. The areas with color represent areas of focus for the viewer, whereas the less emphasized parts of the drawing remain subdued to further accentuate areas of prime interest.

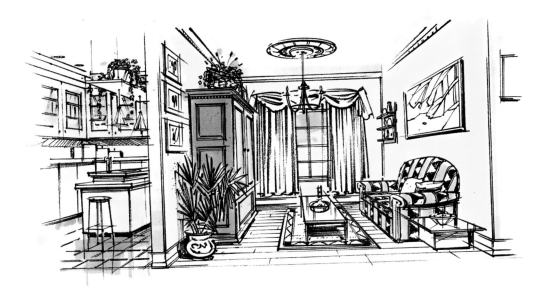

4. Finally, apply harmonious blends and shadows of cobalt blue, red, teal, and beige to complete the scene. The addition of people to scenes such as this can create a sense of relative size and proportion in the room, while clothing and body language can contribute substantially to the mood and setting.

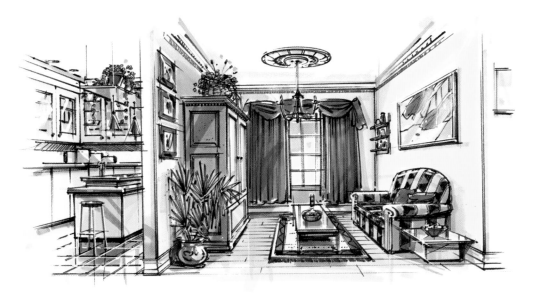

Exercise #10
EXTERIOR RENDERINGS

1. When it comes to exterior renderings, many professionals prefer blueline or diazo prints that possess reproduced images of the original perspective drawing. If something goes wrong with the rendering or if a duplicate is needed, another print is made of the original instead of spending hours redrawing the image. Note: Only alcohol markers can be used on these reprographic papers.

For the sake of experimentation, some artists may find it easiest to work on a familiar surface such as marker paper or vellum. The initial stage should consist of an accurate three-point perspective pencil drawing on tracing paper, similar to the example below.

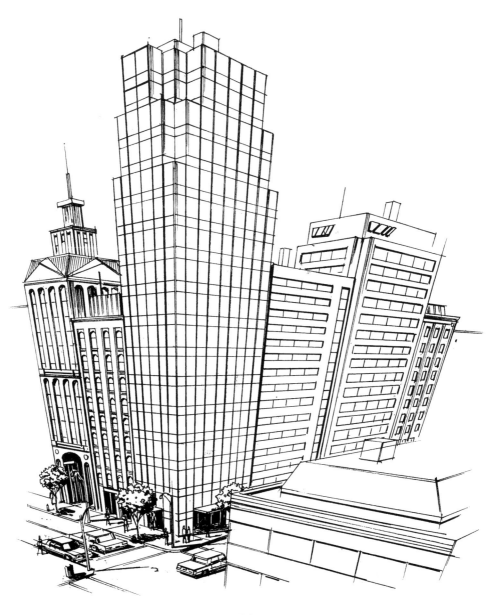

2. Apply blue 0% to the windows. Use warm gray 10%, warm gray 30%, beige, and brown 10% for the concrete base of the buildings and streets. Apply a green-yellow tone to the base of the trees.

3. Add cobalt blue for the cool hue of the shadow on the right side of the buildings, cars, and trees.

4. Now the sky is filled in with a sky blue marker. Note: In this example, an airbrush with white gouache has been used to indicate the clouds, but white pastel would have a similar result. Use the same sky blue to add detail to certain areas of the windows. Add bold contrast and definition to the building structures with black. Add more color detailing to enrich the street, trees, and cars. Use a fine-tip brush to quickly add highlights and reflections. Finally, define the edges and details with white and light blue pencil-crayons. Pencil-crayons make a subtle difference.

TRICKS OF THE TRADE

HOMEMADE MARKERS

Manufactured markers are invaluable for most rendering needs, but with the unique creative demands of the artist, some innovative solutions are necessary. The homemade marker is one example. This is explained in detail on pages 60–61.

PASTEL SHAVINGS

Using a sharp knife or razor blade, shave a colored stick of chalk pastel until a pile of powder builds up on the paper. Then blend the powder into the paper using a cotton ball soaked with rubber cement thinner. This effect will create a textured stroke of color on which you can render. To remove the color, simply use a kneaded eraser.

METHYL HYDRATE AND SOLVENTS

Methyl hydrate is recommended by manufacturers of alcohol-based markers for refilling dry markers. Rubber cement thinner is used with xylene-based markers for the same purpose.

In both cases, the revitalized marker color will be slightly lighter, but that may work to your advantage for attaining those difficult midtones. Rubber cement thinner or some household detergents are suitable for cleaning the drawing table and art equipment around the studio.

OVERCOMING THE DILEMMA OF A WHITE SURFACE

When facing a large white area of paper, many find it difficult to initiate that first marker stroke. If the rendering will be eventually cut out of the paper, you may want to repeat the same object a number of times—if one doesn't turn out, another may suffice. Chances are that you will learn something new each time; thus, improvement is inevitable.

You will usually be able to tell if a drawing will go well within the first few minutes of its inception. If it doesn't seem right, start again. You may have lost a few minutes, but the second drawing is destined to be better. Don't forget, if there's just a minor change required to make your rendering "perfect," you can always patch it in as demonstrated on pages 14–15.

There! That ought to relieve some pressure.

CREATING SPECIAL EFFECTS AND TEXTURES

MARBLE

First, place a wash of ultramarine blue and black on marker paper or vellum. Sprinkle rubber cement thinner over the color, creating a spotted pattern, and then dab with a cotton ball or tissue. When dry, add the veins of marble with black and white pencil-crayons, knocking them back by smudging lightly with a cotton swab or your finger. Remember, this is a glossy surface that picks up cool tones and highlights, both of which can be added by airbrushing with white paint. The same effect can be created with white pastel.

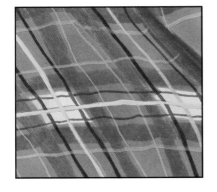

STONE

When rendering hard rock surfaces, the primary focus is to determine the source of light. First lay in a cool gray 20% wash. While still wet, apply cool gray 40% and then cool gray 80%. This gradation will represent a smooth stone surface. With a toothbrush or flat brush, spatter black or dark gray gouache onto the paper by placing your thumb onto the bristles, pulling back, and letting go. With a fine-tip brush, paint in white highlights below each of the dark spots to represent fine holes on the surface.

SHALE

Initially, lay down process blue, followed by cool gray 60%. Depending on the light direction, strategically apply both black marker and white pencil-crayon to create the illusion of highlights, shadows, and crevices.

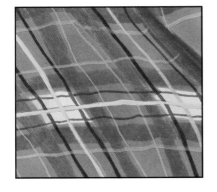

PATTERNS FOR FASHION

A combination of gouache, fine-tip markers, colored pencil-crayons, and good reference are needed. Occasionally, the demand for highly detailed work will arise, as this example shows. On the other hand, "looser," quicker renderings usually serve to capture the mere essence of the design. In general, a suggestion of a pattern will suffice. This is exemplified by the figures' shirt collars on pages 22–23.

HOW TO CREATE YOUR OWN MARKERS

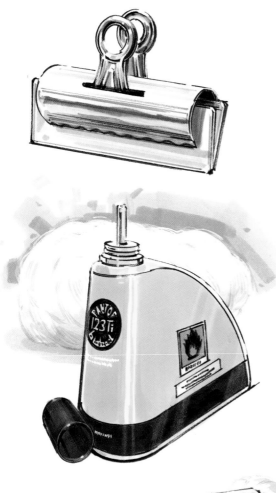

As briefly discussed on page 58, home-made markers are great for attaining effects unlike any other on the market. A very wide marker can be made by placing a few cotton balls in a bulldog clamp and pouring ink onto the exposed cotton. This is a good tool for rendering skies, water, and loose backgrounds. The illustration below shows how the clamp is held while rendering a large area.

Note: Some companies now make large foam markers with cardboard handles. These markers work well, but they are rather expensive and can usually be used only once.

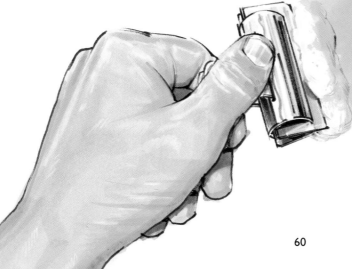

The loose background here has been rendered with a homemade marker: cherry red ink was soaked into the cotton. The red "swish" effect against the close-cut, detailed rendering in the foreground provides dynamic contrast for presentation. This technique is also exhibited in the illustration at the bottom of page 45.

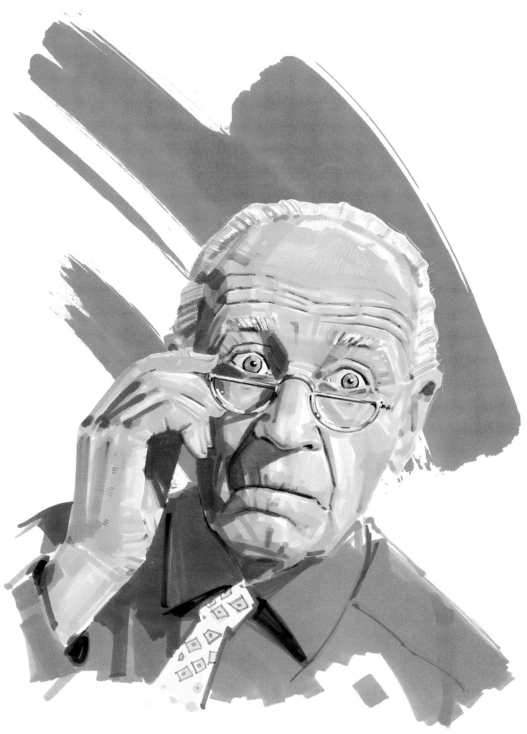

LIQUID FRISKET/MASKING

When you are rendering a large area with a xylene- or alcohol-based marker and want to retain particular areas of white, you may want to mask those areas with liquid frisket. This masking material allows you to lay in broad, quick, confident strokes without having to stop or slow down around areas of detail.

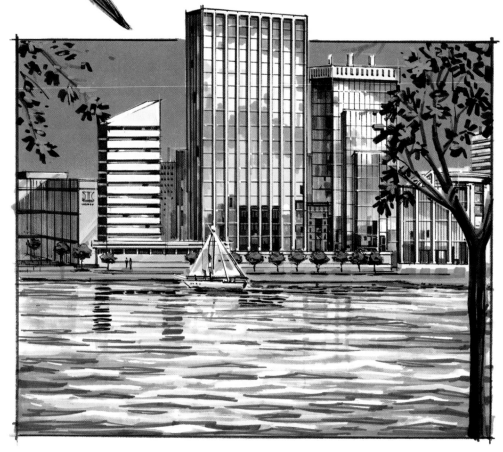

For the example below, before any rendering takes place, fill a ruling pen with liquid frisket and draw it over the lightest areas of the office towers. (Use a straightedge to draw the vertical lines.) Once the frisket is dry, apply the blue tone over it.

With a brush, apply the frisket material to the area where the whitecaps on the lake will be. Then render the various reflective tones on the water. When dry, rub off the liquid frisket to reveal the white of the paper—that is, the whitecaps.

In the event your brush becomes sticky with residue, try cleaning it with rubber cement thinner.

As with rendering in marker, work in a well-ventilated room when working with liquid frisket. It may come in a small bottle, but beware: it has a big smell!

PROFESSIONAL PRESENTATIONS

As stated in the introduction, marker rendering centers around illusion and impression. To maximize these qualities when "selling" the concept to the client, an organized, clean presentation is paramount.

Many artists and studios have distinct presentation styles and materials. The following examples represent the more classic approaches.

Mount the artwork on a thick, two-ply art board. Tape protective acetate or tracing paper over your work to protect it from exposure and smudges. Finally, place cover stock on the front with the folded flap glued or taped to the back.

A second alternative is to mount the rendering on foamcore, so it is actually on a raised surface from the matt board. The foamcore should be a complementary color or tone to enhance the important aspects of the rendering. To finish, glue or tape a cardboard easel to the back of the mat. When the artwork is freestanding, the presenter's hands are also free to point out specific elements of the rendering.

When presenting artwork in a portfolio, it is important that everything is clean, standard in size, and placed in a logical pattern. The background paper in the acetate sleeve should also complement the artwork. A brief description for each page clarifies individual renderings. Not only does it look more professional, but many times your "book" must be left with a potential client or employer to view at their convenience. Your entire portfolio should be self-explanatory.

There are differing opinions on how to best organize a portfolio. I feel it should consist of no more than 10 to 15 pieces of artwork. Your best renderings should be on the first page, the second best on the last page. As the saying goes, "If you have any doubt, leave it out!"

Once you are comfortable with your selection of art and the arrangement, show your book to friends and family. Their praise may be nice for the ego, but listen to their questions and comments. They may notice something you overlooked. Eventually you'll want to show it to as many professionals as possible and ask for their feedback. They may refer you to other professionals in the industry where your portfolio will get maximum exposure.

Good luck!

I'D LIKE TO THANK. . .

Walter Foster Publishing, who gave me the unique, exciting opportunity to create this book.

My wonderful wife, Lisa, who inspired, supported, and offered me insight throughout this project.

Bob, who catalyzed a spark in me that I didn't know existed.

My family, friends, clients, and students who encouraged and assisted with invaluable feedback.

Sandra, who took the original, hackneyed manuscript and magically turned it into something that I could be proud of.

And you, the reader, whose interest in a book on rendering techniques not only stirred a market demand but a demand within myself. If this book sheds a new level of perception and inspires you to want to learn more, I feel it has done its job.